lIFE

aBSTRACT

By, J.C. Bellerive

Copy right 2016

All rights reserved.

ISBN-13: 978-1533635921

ISBN-10: 1533635927

EARTH

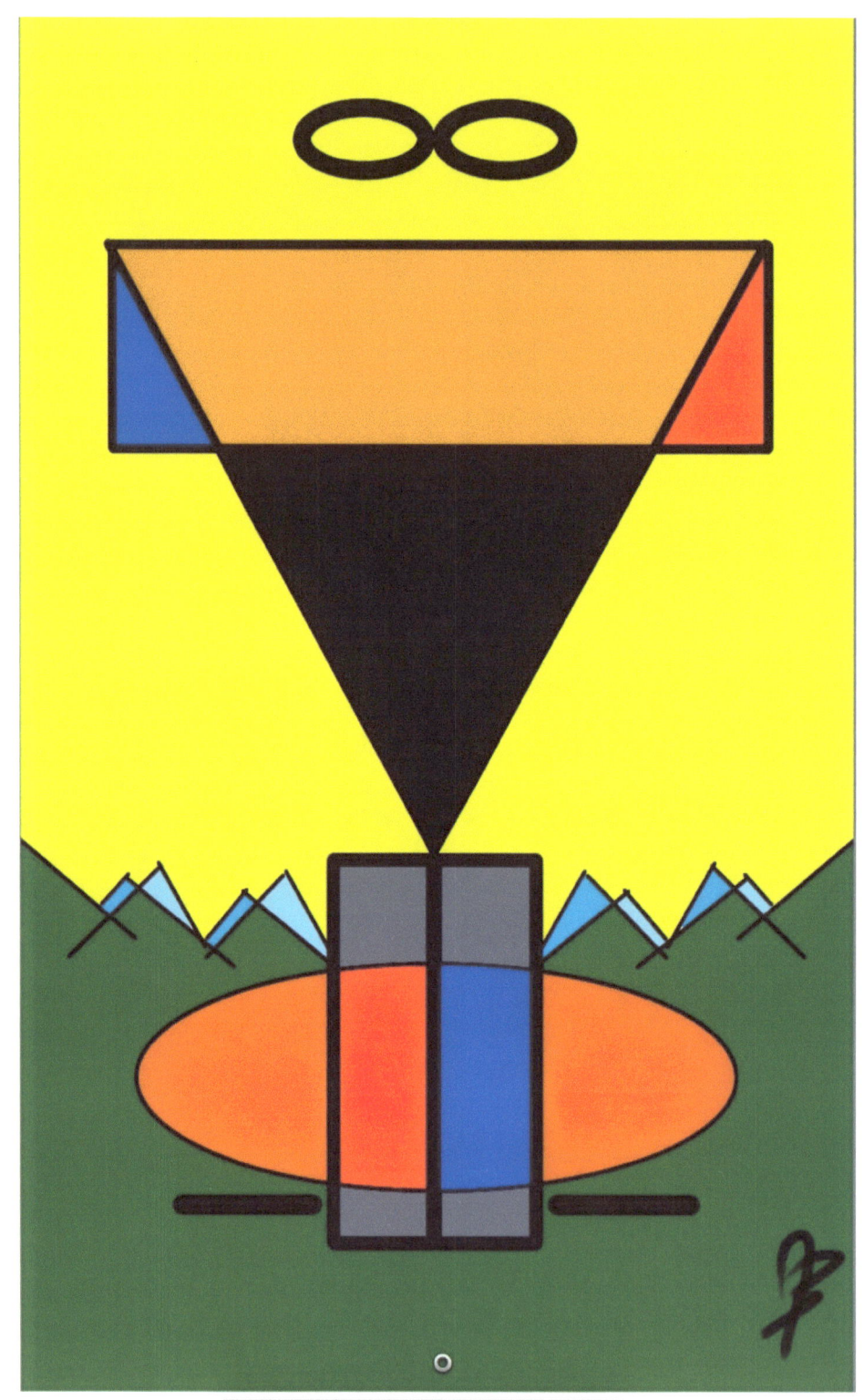

STRENGTH

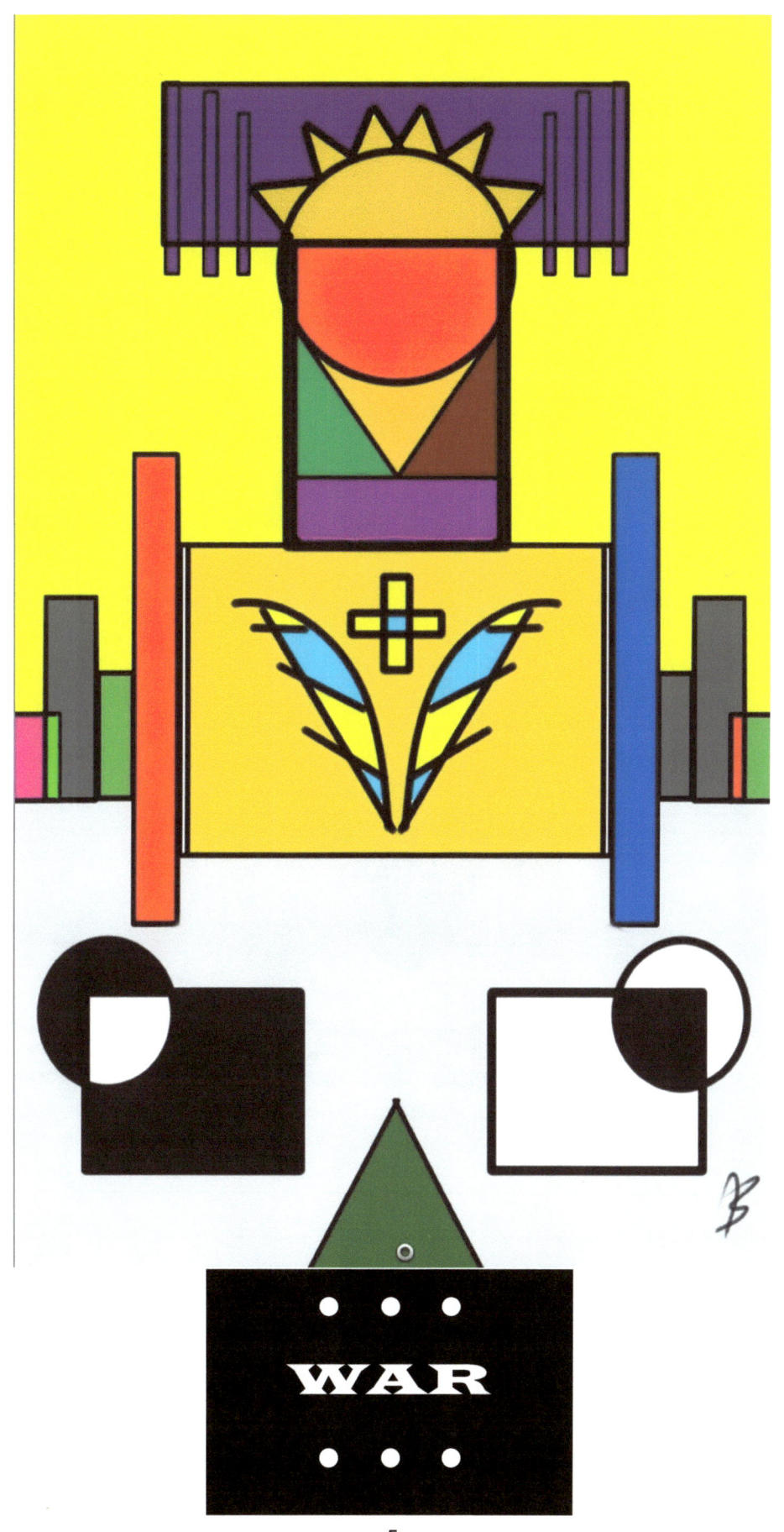

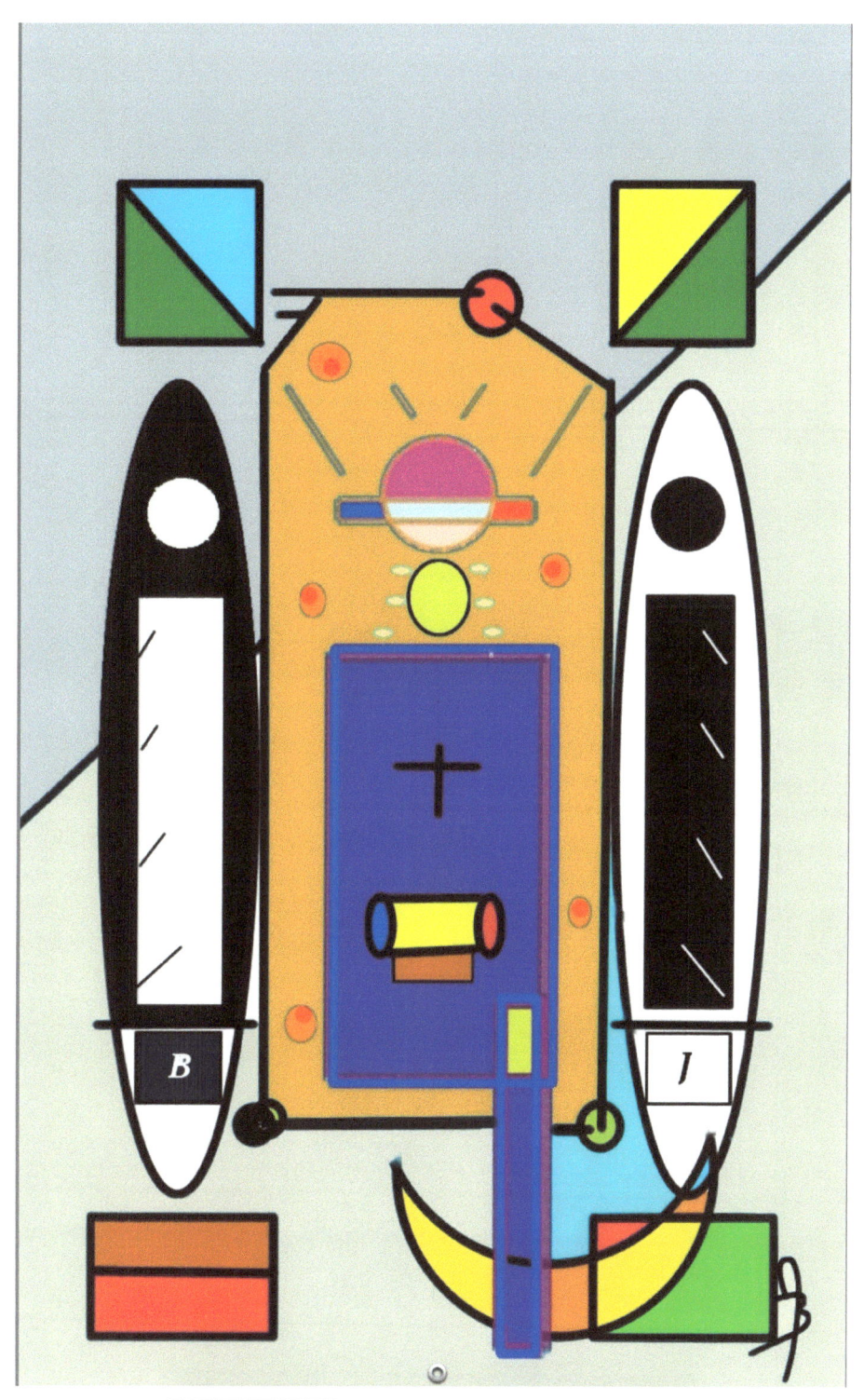

KNOWLEDGE

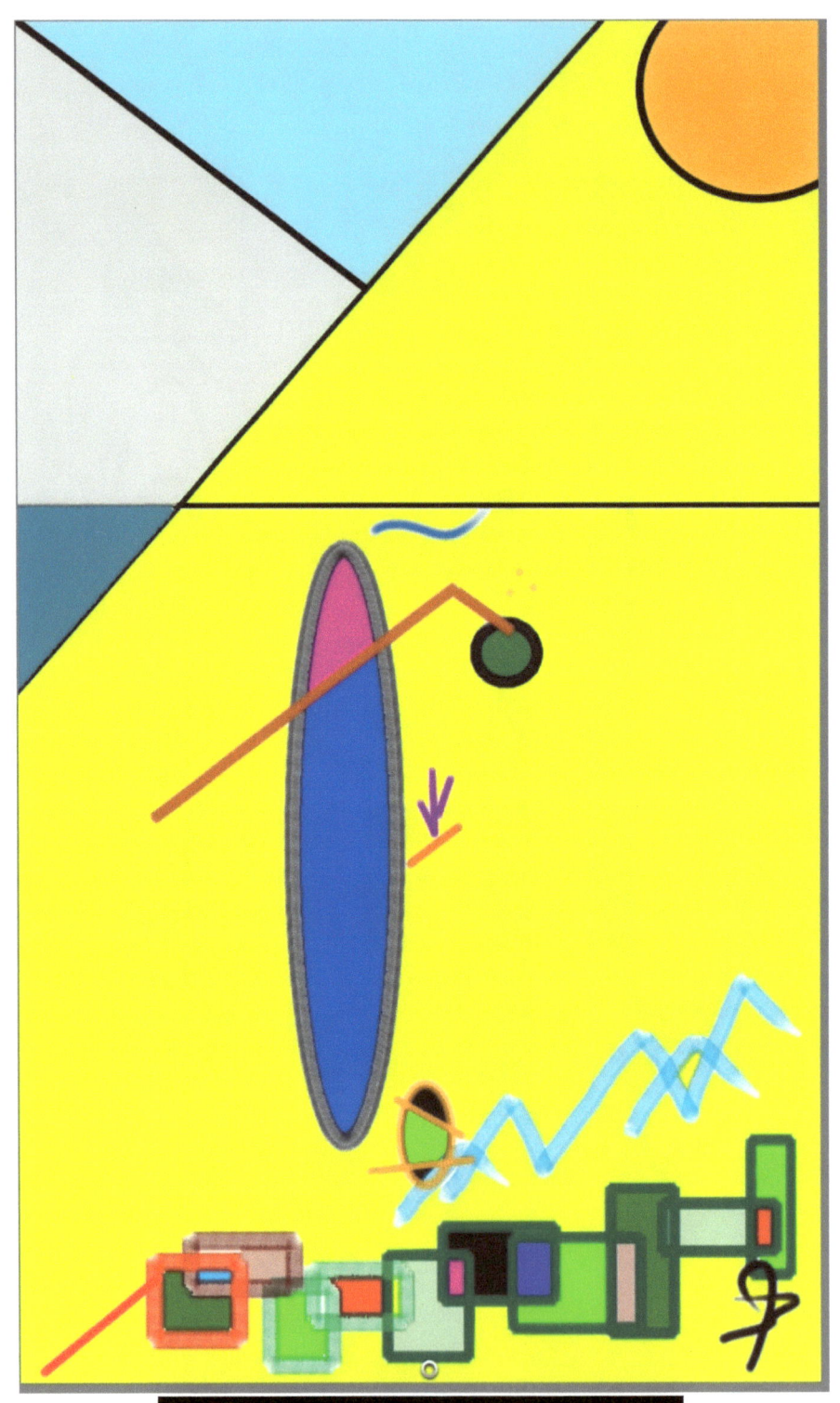

CAUTION

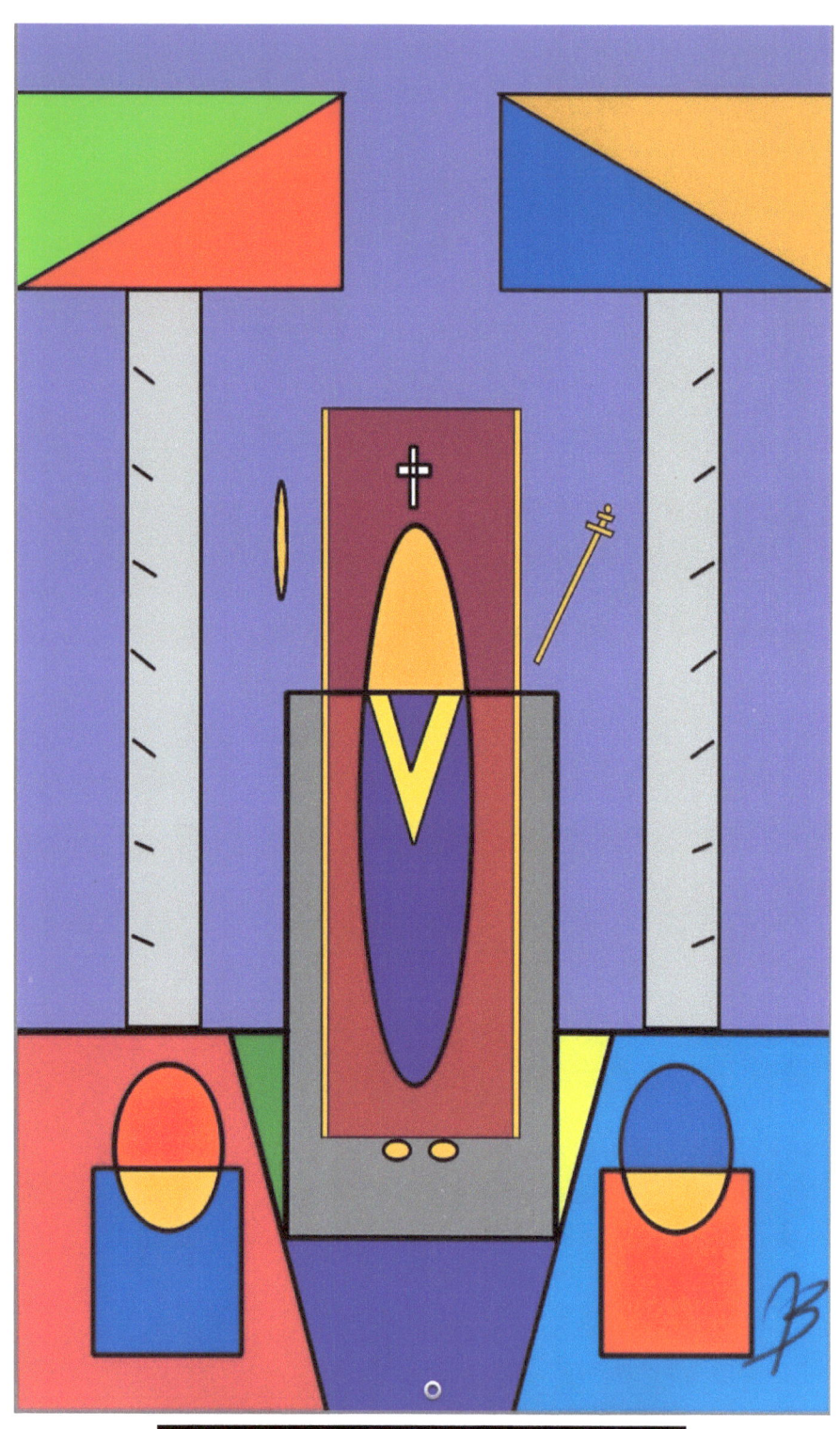

SERVITUDE

CONTENT

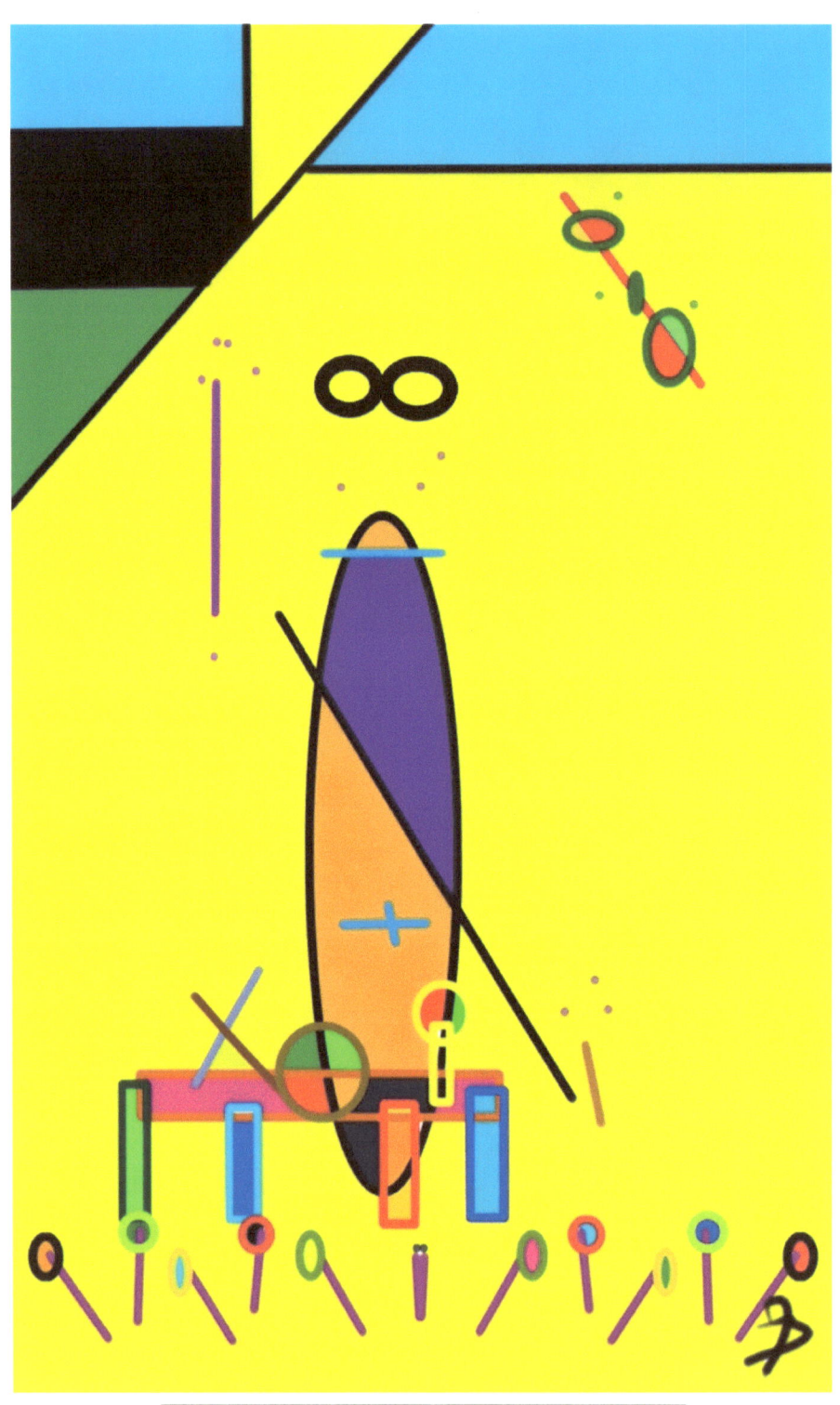

TALENT

WISDOM

FINALITY

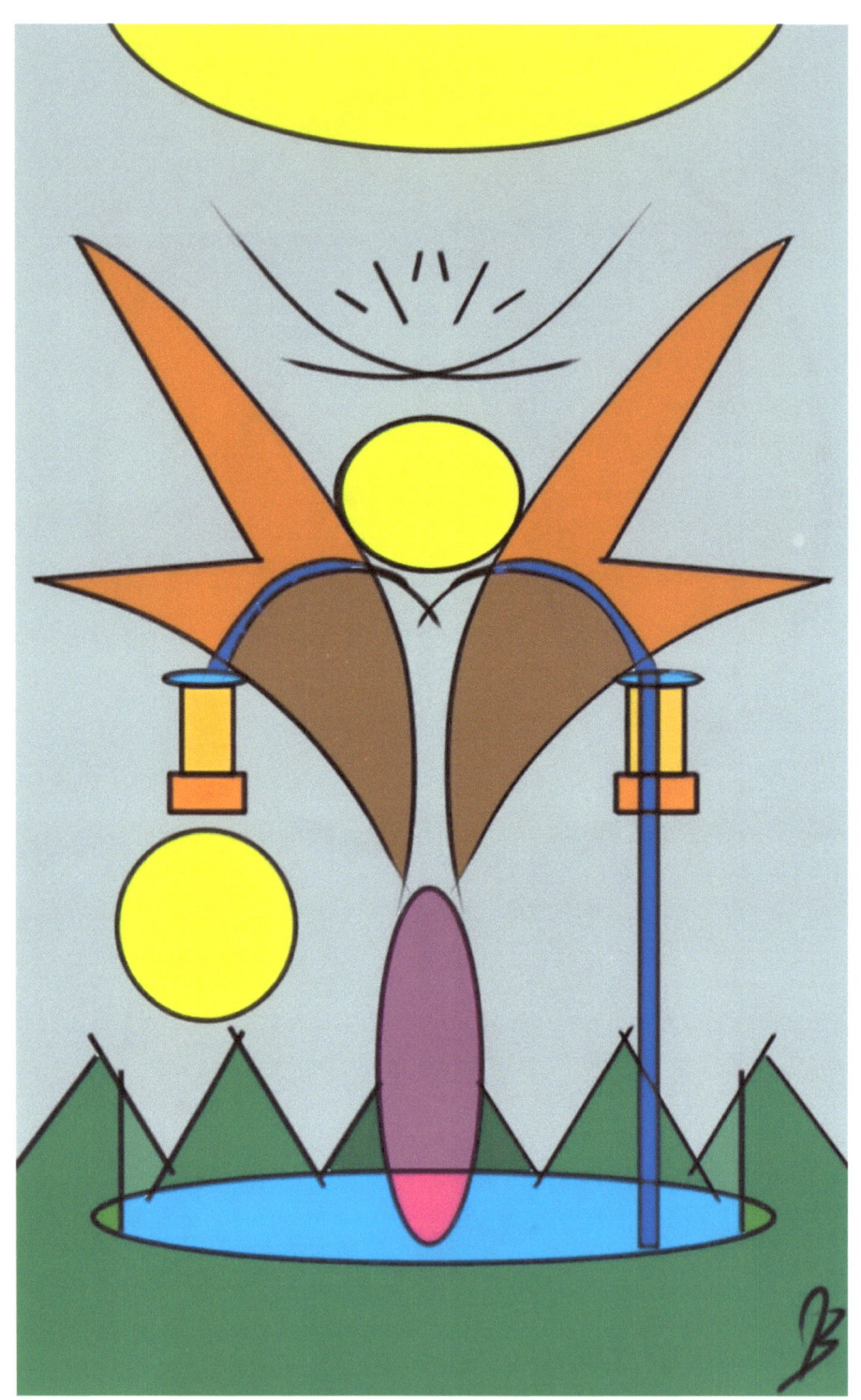

FAITH

TEMPTATION

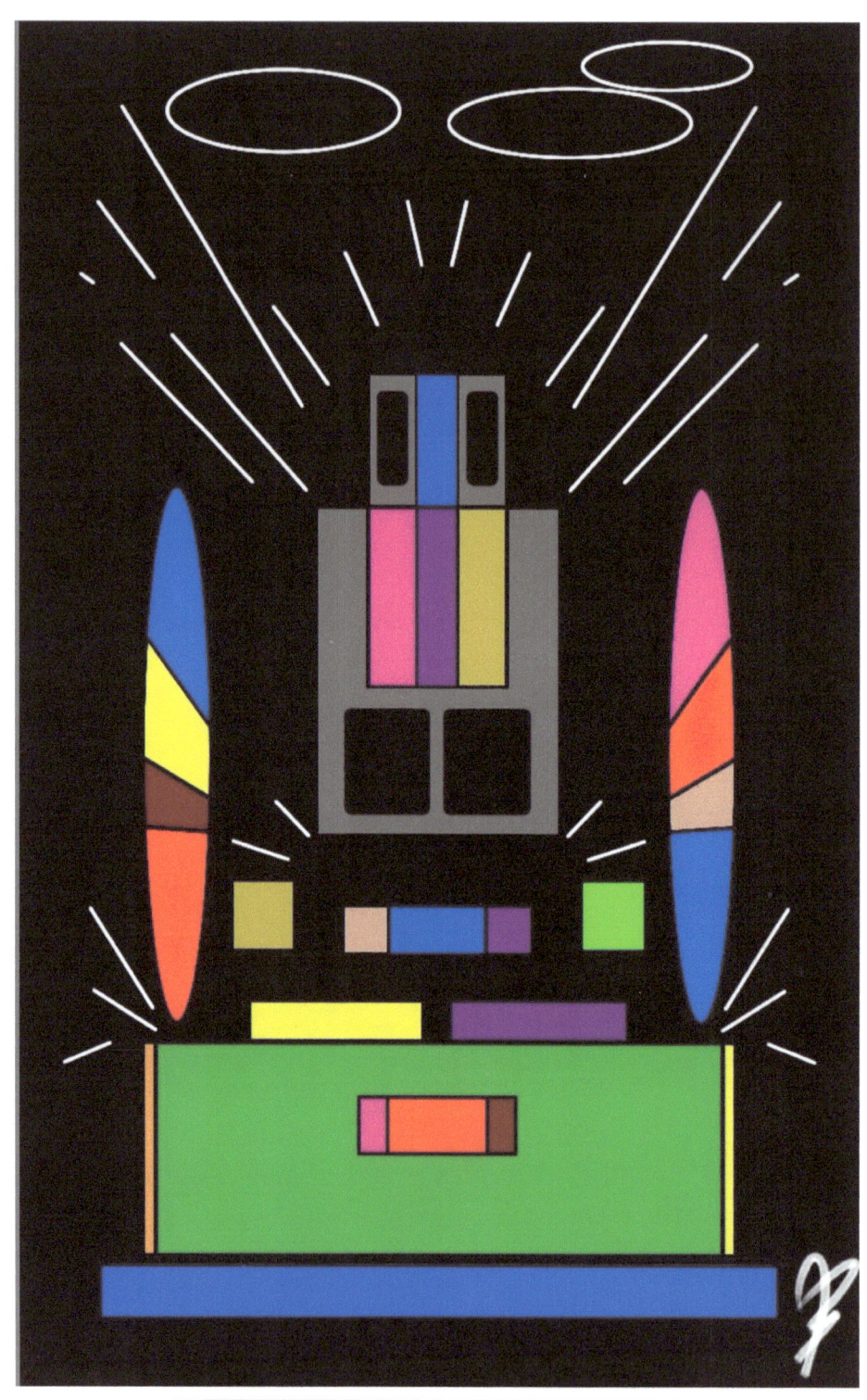

DISTRESS

HOPE

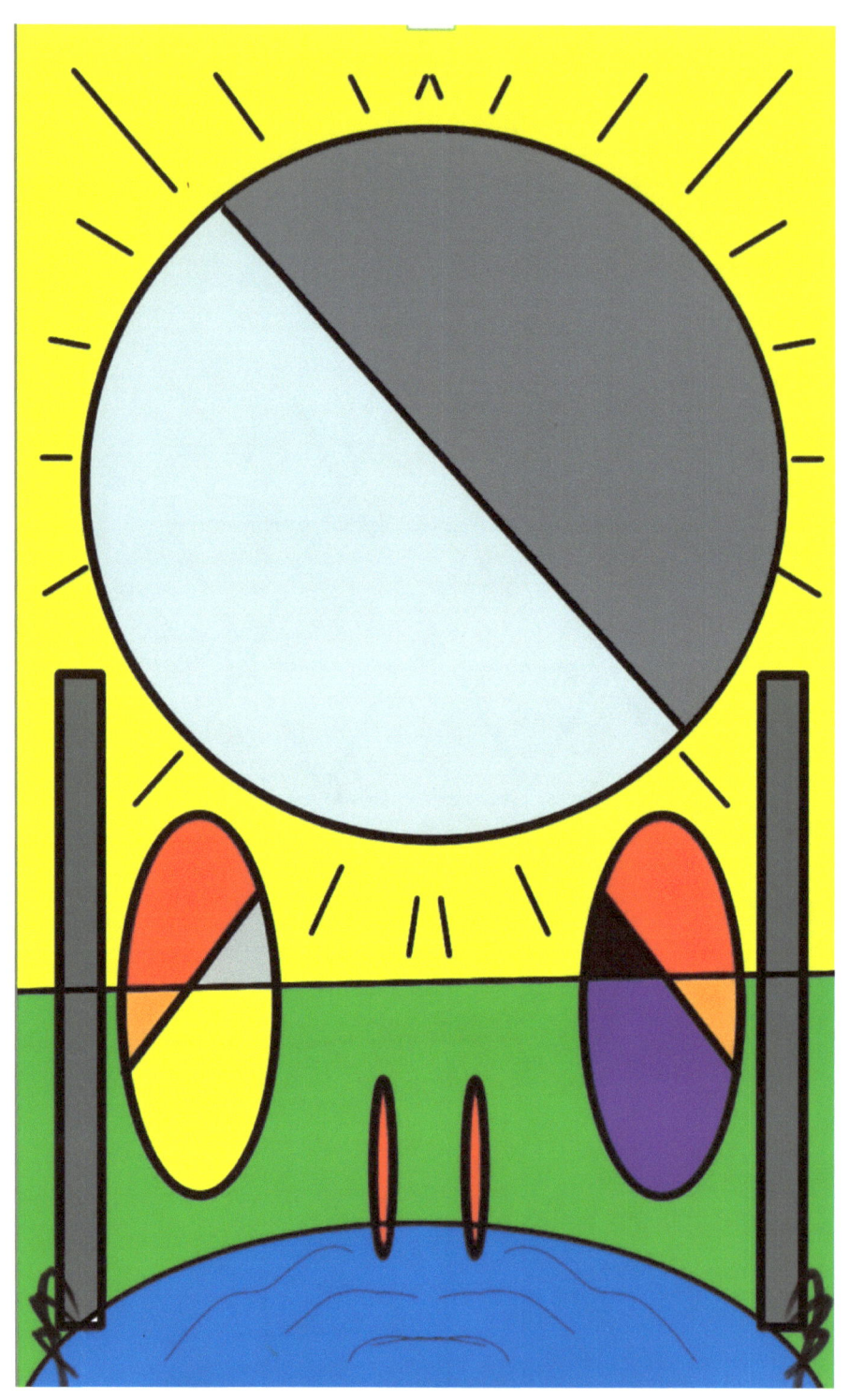

SOLITUDE

PEACE

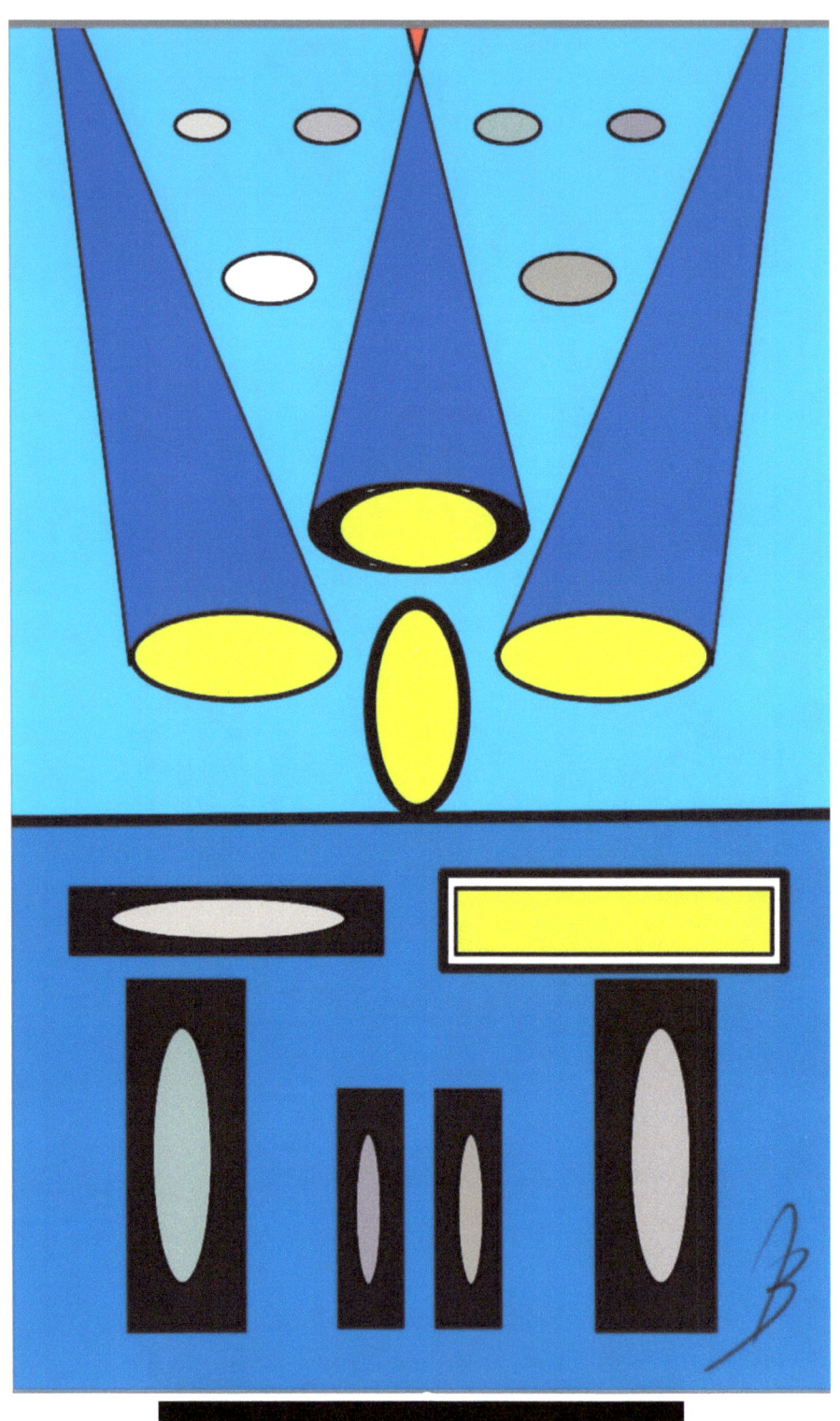

DECISION

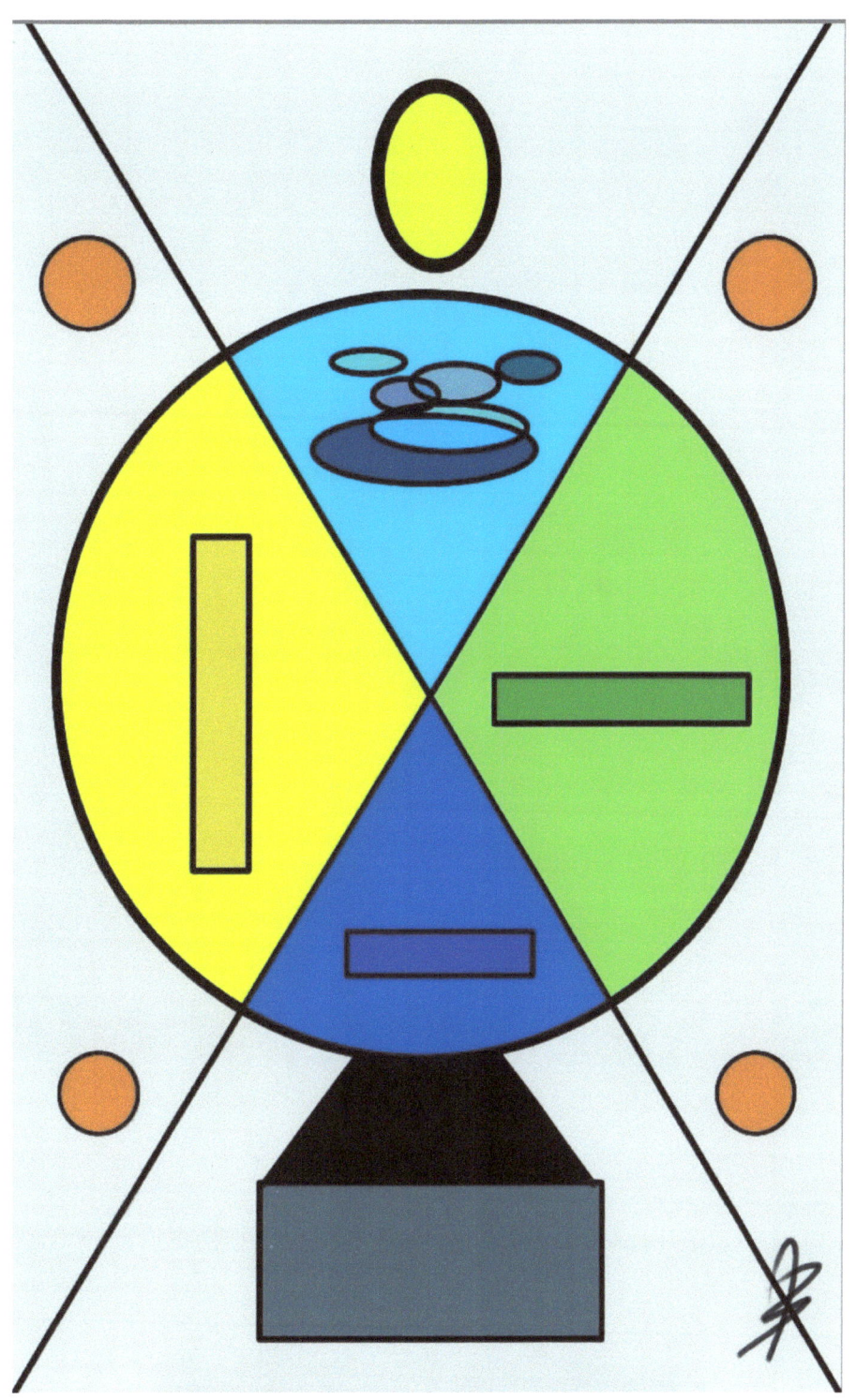

FORTUNE

www.ingramcontent.com/pod-product-compliance
Lightning Source LLC
Chambersburg PA
CBHW050438180526
45159CB00006B/2587